Rosemary Sassoon

THE POWER OF
LETTERFORMS

The Queen's book

gulliver's travels

lord of the rings

uncle tom's cabin

Lyoness

Organic

QUIET
please

Rosemary Sassoon

THE POWER OF LETTERFORMS

Handwritten, printed, cut or carved – how they affect us all

First published in the UK in 2015 by Unicorn Press Ltd

Copyright © 2015 Rosemary Sassoon

Rosemary Sassoon has asserted her right under the Copyright, Designs and Patents Act, 1988, to be identified as the author of this work

A catalogue record for this book is available from the British Library.

978-1-910065-55-6

Designed by Blacker Design, www.blackerdesign.co.uk

Printed in India by Imprint Digital Ltd.

Contents

The twelve letters of this word express so eloquently its atmosphere and meaning.
'I wrote this in the peaceful moments after a long day's teaching in Tokyo –
perfectly relaxed,' explained Ewan Clayton.

Introduction

Those of us whose interest and careers are in letterforms are a relatively small group of individuals. Whether scribes or less formal letterers, typographers, type designers or letter cutters or even those interested in handwriting, we can communicate with each other. We form firm friendships even though we may disagree about some things, sometimes. Outside our field we meet with total incomprehension, even incredulity, that we can fill our lives in such a way.

Someone may just have made an extravagant purchase that they can ill afford, seduced by the elegantly designed box that it was displayed in. Another person may have purchased a packet of biscuits or chocolate bar without really considering the contents, because of the delicious feeling that the packaging promoted. They will have discarded that box and those wrappers without a single thought, not realising how they had been manipulated by the lettering and design.

When it comes to handwriting, people do not realise how their attitudes have been formed by how they were taught – whether it was a pleasurable experience or a misery. They deserve to understand how this may have affected their creativity, their

careers and even their health. You may not notice the difference that the typeface of a book makes to your ease of reading, but the way the instructions are laid out on pamphlet that comes with your chemist's prescription makes all the difference to how you understand its contents – or even bother to read it.

Let me explain the sequence of skills involved. Handwriting is everyone's skill. We can either consciously or unconsciously affect its forms, adapting it to our needs, but essentially it is the reflection of our self on paper, the natural trace of our own hand.

Formal writing, pen lettering or calligraphy, whatever you choose to call it, is to a certain extent affected by the implement used. The broad-edged nib controls your hand and forms the basic letters. Once having perfected the model, and learned to control the spacing you can forget about the actual production of letterforms and be more creative, but this takes time. Tension and hesitation may still be evident early on. There is the worry of how to deal with spacing when you get to the end of a line and fear of spelling mistakes always at the back of your mind. It is not easy to explain how you can be affected by the content of your subject in a way that the emotion that the text evokes in you shows through your letterforms. Eventually the purpose of whatever job you are undertaking will govern its atmosphere and it will be evident through your work, leaving you to be more creative if demanded.

Next comes freely drawn, painted and designed letters such as those needed in imaginative advertising, packaging, and for designing book covers, logos, etc. Once this would have been considered comparatively easy, but not today. It should be relatively simple to use your imagination to reflect the image you want to project, but I suppose you need a repertoire of forms in

your mind to be free enough to reject pre-designed models and just go for it. This is now the kind of lettering I enjoy teaching, releasing the designer's imagination to flow freely and react to any circumstance.

Next might come typography and type design. Each letter of a typeface must be perfect in itself, and fit well with every other letter in the alphabet irrespective of whether it is being designed for a certain purpose or to be a creative or commercial enterprise. It is a highly skilled profession, no longer involving casting in metal but, once designed, involving many hours of work in perfecting and digitising. Last of all comes letter cutting in stone, slate or wood. It is a traditional, essential and serious craft taking many years to perfect. Designing a meaningful and beautiful memorial in discussion with the bereaved, or fitting a plaque or integral message in with the architecture of a national monument, their work has to stand the test of time. Many of the exponents of these differing areas of expertise first learned about formal letterforms through calligraphy. Their work impinges on all our lives.

A more personal note

I cannot remember exactly when or how I learned to write. I can remember, however, precisely when I first became intrigued with letterforms; I was aged thirteen. It was the end of the war and things were very unsettled. At school the teachers were tired and often bad tempered, but the art room was a haven of peace. We were taught lettering amongst other things, and somehow I found that learning classical models, practising them (I will not say perfecting them) and writing out my favourite sayings and poetry, both satisfying and soothing. I still have some of those early bits.

Little did I think that this fascination with letterforms would turn into a lifetime's interest — some people might say obsession. I left school early, and art school beckoned. Luckily there was a talented lettering teacher, but after a year it was on to more advanced study. The training, or rather re-training with M C Oliver, a master scribe, and one of the great successors to Edward Johnston, was unchanged from what it had been for centuries. Using first of all the Foundational model, we were trained to replicate our master's hand precisely. We were proud to do just that, and it was only years afterwards that I felt that this method somehow stifled creativity.

Then my character began to show. I felt that I would never be disciplined or dedicated enough to stick to the kind of traditional scribal jobs that were then available. I felt that I was more of a designer wanting to use letters in other ways. Although I was to undertake what would now be called calligraphic commissions for many years, it was to a very different kind of lettering that I turned. Working as a packaging designer in the 1950s, before the days of computers, meant that you had to draw all the lettering by hand. It was fun. You could invent and adapt any style you wanted from classical to modern to suit the character of the product that you were designing for. Brush scripts, freer, bolder and more flexible than your own handwriting were very useful. All this taught you how different letterforms changed the atmosphere of a design or logo and influenced how a customer might feel about it. Much later on I learned more about the way the atmosphere of typefaces can affect the reader in the same way. The public seldom realise how such things manipulate and affect them in their everyday life. I hope that this book will ensure that people will look at letterforms differently from now on.

Eventually, when the craft became popular once more after years of neglect, I decided to write a book about lettering (or calligraphy as it was beginning to be called). I wanted to open it up to ordinary people not just skilled art students and others. In order to see if my method would work I really needed to start teaching. Luckily an opening arose in adult education, the first classes to be held in my part of the country.

Then something unexpected occurred. I got a call from my local educational authority. They asked that as I now taught lettering would I teach their teachers to teach handwriting, completely misunderstanding and confusing the two disciplines. I did not think it was really my area at all and I did my best to persuade various colleagues to take up the offer, but nobody wanted the job. So, knowing little about teaching handwriting to young children, except how badly our three daughters had been taught at school, I accepted and embarked on a journey that was to take much of my time for the next twenty-five years. It led to researching and developing the medical as well as the educational aspects of the subject, and eventually to find out how letterforms could affect the ease in which young children learn to read.

Chronologically, the study of handwritten letters came quite late in my career, but I am going to start with them. I feel that to explain their influence on our lives will most easily lead to an understanding of how other forms affect us all, often without our realising it.

Brown beef and onion together.
Add the remaining ingredients.
Add salt and pepper, to taste.

FAN Tsue Tsuan painTing ExhibiTion in
Xili picTure Gallery of Shen Zhen

[phone. have not seen him yet - and he asked if
you hadn't also found his kite - I believe he
said. - He had simply forgotten that he had put
all the presents under the bed, so he was sorry you]

based on everyday lives.
The characters are very
good, but Hilda Ogden is
the best, she is a middle

Your handwriting can indicate where you come from, how old you are and much more.

"Writing is much more than a mere record of speech... It communicates through different senses, colour, shape, heft, texture. It also has a different relationship to time. Its substrates can last for a long period, often way beyond the lifetime of the author. It can physically travel through great distances, it can be constructed collaboratively, its length can go on and on far longer than someone can talk without pause. It can be revisited."

This relevant quote comes from Ewan Clayton's 2014 book *The Golden Thread, The Story of Handwriting.*

Part 1

Understanding the Effects of Handwriting

Before considering the influence of formal letters it is a good idea to discuss the effects of our own, handwritten letterforms on ourselves as well as on other people. We are often judged by our handwriting, however unfair this might be. Why is it so unfair? Those lucky children (and adults too) with good co-ordination and hand function learn to write easily and go on to develop attractive scripts. Those perhaps more clumsy people, whether with a serious defect or not, may struggle throughout their lives through little fault of their own. Those well taught, with teachers who know how to teach and can inspire their students, do well. Those, and unfortunately there are many today, who are not taught adequately suffer, and later on, in secondary school, are blamed for not writing properly. This criticism alone can blight a student's life. What individuals may perceive as a bad or immature script is, for them a constant, visible trace of failure. This may affect their whole attitude to learning and creativity. To make

your mark, in a graphic sense, is a basic human need, and has been since the Stone Age. Before we discard it as redundant, and if we are to continue to teach, use and value the written trace, it is important to understand what it means to us all.

Handwriting is, above all, a tool for communication.

As Percy Smith, the famous letterer wrote: 'Handwriting ranks with speech and gesture as a necessary means of communication.' That was many years before computers appeared on the scene, but it still remains true. There are still many tasks where personal writing might be better than a computer, such as jotting down a message, quick notes (or even longer lecture ones) or a shopping list. For these tasks it is often more practical, and for a love letter or formal letter of thanks it is perhaps more desirable.

The content of what you write may differ depending on what method you use. When you write by hand it is straight from the brain via the hand to the paper. It is immediate and often more intimate. Ask any poet for instance and they may well say that to create anything sensitive and meaningful they need to compose by hand. The text generated by computer is often a bit different. You can edit it, revise it as you will, so it may become more correct but has lost its spontaneity and has perhaps become less personal. It just depends on the person which is preferred. It is ideal for academic writing and I am daily thankful for my faithful Mac, particularly now I have had a stroke and my right hand does not function very well.

Some people think differently to this as Ben Macintyre pointed out in *The Times* (23.11.2012). He quotes Iris Murdoch as saying that she wrote all her 24 novels by hand and dismissed the word processor as a glass square which separates one from ones thoughts and gives them a premature air of completeness. He added his own comment: 'What we write with shapes, how we think, be it quill or keyboard'.

I can understand Macintyre's view although in a slightly different situation. I sometimes notice that a graphic or other designer has stopped too soon, before reaching the best possible solution to their work. This may well be because the computer screen can give a false impression of perfection of a particular layout or design. Alternatively, a new look is often the product of a second look. Maybe there are compromises. There already are pens that allow everything you write to be transposed in to text to store on your computer. Maybe all this will change for the next generations who will have been brought up almost exclusively with ever more ingenious technological aids – but maybe some things will be irretrievably lost.

It is a reflection of your self on paper.

You do not need to be a graphologist to understand this. You write with your hand, part of your body, and this reflects both your feelings at the time of writing, and your character. Some people say that your adult writing reflects partly what you were taught and partly who you are. I do not necessarily agree. Strong characters deviate very soon from their taught model, and creative people quickly show their originality through their script

day i it left
me doing au sort
of only things!

There are a multitude of personal scripts of all styles and sizes. You do not need to be a graphologist to see how they tell you a lot about the writers.

I am just writing to ask you if you are
feeling any better. You certainly appeared to be
somewhat under the weather when I saw you last

any way aval
Would there be
remote chance

of course I can't be certain of success.
But if one waits for certainty, one waits
for ever. It will all be on a much

(perhaps with the exception of where national models are strictly enforced). When they have been made to closely follow any of the various models used in our schools, and found it successful and satisfying, or have been praised for their diligence, it is the often obedient ones or those who are not so confident who do not develop further and are left with quite a juvenile handwriting.

Do not forget that your genes may also play a part. Have you noticed how some family members may have similar writing? They are not necessarily consciously copying each other but they might use their bodies in the same way. Therefore their hand movements are similar and result in similar scripts.

Your writing will reflect your mood particularly whether you are tense or relaxed. Just looking at a sample you can feel whether the pen has raced smoothly and freely over the paper, dug deeply into it through tension, or where the writer hesitated. When you are tired or perhaps exuberant this will show. This shows through your normal writing but your script can also reveal much more.

Affectation and pretentiousness leave their evidence. Those who try to appear something that they are not, whether by adopting what they consider an elegant or grandiose style, or trying to copy the writing of someone they admire, can also be spotted. Then there are signs of such characteristics as dishonesty (although personally I do not know how to detect them). These are some of the markers that explain why companies employ graphologists to vet the written applications from would be applicants for new jobs.

Handwriting can reveal the nationality of the writer. Many countries, the USA in particular, have such a firmly entrenched national model that their handwriting is unmistakable. The Zaner Bloser model, well over a century old, is beginning to lose its

and all the children
to organise their
the each other's. routes.
behaviour. problems
and resources sidering the
and Part the we ren scheme
and site the red out
I bad were only we
um to condit

sonally interested in. It was
t a large proportion of these
rt and craft. We felt that all
I would enjoy some of these
ll it was their ½ term holid

nication betw
ation
polytechnic staff should
ed well in advanced
dents do not have to
ning would
ae children to receive
operiences possible.
and also ensure that all areas

A collection of samples written by students at a teacher training college.

influence, however, as commercial cursive becomes inappropriate for fast writing and modern usage. Many continental European models also leave an indelible mark on a writer's script, with only the strongest characters breaking away and developing their own personal handwriting. I feel that the script of some countries has become somewhat of a cultural indicator that they seem unwilling to give up, in the way the American model bonded an immigrant population together with a common visual trace.

Handwriting is a motor skill.

How would this affect you? When learning any motor skill whether it is ice skating, ballet, gymnastics or handwriting, the movement, whether of feet or hands or any other part of the body, has first to be learned. Then the movement is stored in the motor or muscle memory, that is the way our bodies work. Once automated you just perform the learned movement automatically when needed.

This underlines that handwriting is a taught skill, not something that might come naturally to humans. Once learned, you are free to concentrate on the content of what you write without considering how to do it all the time. It is, however, difficult to alter that movement because you would consciously need to make your body do it, although of course your script develops and changes as you do. Think what that would do to what you were writing, interrupting your flow of thought each time you wanted to alter the style or movement of a certain letter. That underlines the need to automate the correct movement of letters from the start, irrespective of style.

Wilfred Blunt was an enthusiastic exponent and teacher of Italic handwriting. It was, however, well known that his fast personal scribble was anything but perfect as illustrated in one of his letters to Kathleen Strange.

Wilfrid
Blunt

Sweet Roman Hand

five hundred
years
of
Italic
Cursive
Script

LONDON
JAMES BARRIE
1952

1. ABCDEFGHIJKLMNOP QRSTUVWXYZ. 2. abcd deefghijklmnopqqrstu vwxyyz. 3. ABDEHMWD 4. acg not acg. 5. boy, boy, or boy. 6. ddd. 7. ee met, rend, me and. 8. f, not f. 9. k. 10 m, not m or m; n, not u or n. 11. p Qq. 12. r, not n or v. 13. sat, not sat; as, not as. 14. act, fast.;: 15. to, not to. 16. very. 17. W, not W or ω. 18. axe, not axe. 19 y or y, not y. 20 Z, not z, && & Italic, when once acquired, should be written easily & as quickly as possible. ✓ WB.

It also underlines the need to pay attention to any awkward aspect of writing posture that also becomes so automated that it is hard to change.

It is a reflection of usage.

This means that you need and probably have several styles or levels of handwriting depending on the task before you. Even perfectionists have a fast scribble, in fact having several kinds of writing is the mark of a practical, efficient writer. It certainly is not something to be ashamed of. Of course it may depend on how much time you have available at any given time but first of all you need to decide whether the writing is for you alone to decipher or whether it is aimed at other people. This is a good place to discuss what is perhaps the main usage of handwriting today and in the future. For students an important usage is taking lecture notes. However scribbled they are they will need to be deciphered at a later date. For anyone passing on precise instructions, legibility comes first. When you want to make a good impression then your best hand comes into use, and for informal correspondence between friends or family half way between is fine. Sometimes these differences will be conscious, sometimes not.

There is always a trade off between speed and legibility (unless you are exceptionally lucky and skilled). The only advice that can be given to those who think too quickly to get their thoughts down legibly, is to be more precise in their thinking – but that is not easy either. Looking at some teenager's examples it is hard not to pity the poor examiners who have to decipher their

This is a sample of my decorative

Copperplate Script

My Formal Italic has a little Bounce to it! It is a reasonably quick hand

T This is one of our modern scripts that looks more typographic!

This is the hand I tend to use for my own note taking on or in my sketchbooks & on my iPad with a stylus.

I ALSO SOMETIMES USE THIS CAPITAL CURSIVE SCRIPT IF I NEED TO SAVE SPACE OR MAKE SOMETHING BOLDER.

I am sometimes inclined to use this depending on my mood.

The calligrapher, Paul Antonio, shows the variety of scripts that he uses for different purposes.

essays. Although it is vehemently denied, it is impossible not to think that sometimes it would affect the marks they award.

People's concept of what writing should be can also come into the equation. It may seem odd to say that it is sometimes a disadvantage to have too high an idea of what good handwriting is. This can mean that nothing short of what they perceive as perfect seems acceptable. In some cases this severely affects how fast a person could write. Imagine how this limits the amount that can get written down under examination conditions.

Handwriting is the visible trace of a hand movement that is in turn affected by your entire posture.

This is often forgotten, as if the letters appear on the page by magic. The actual hand is ignored and a mythical correct way of holding the pen is prescribed and that is deemed all that is necessary.

Look around in any office and you will see people writing, seemingly adequately, with anything but a conventional pen hold. Does anyone ever consider why? Again we first have to look at history. It was perfectly reasonable to prescribe an optimum penhold for the quill or pointed metal nib that came into universal use for writing copperplate. Even so, that altered from writing master to writing master in previous centuries. Today we have a multitude of writing models and implements but no one seems to consider that they need or promote different penholds, or whether those unconventional penholds have implications for either the written trace or the writer's comfort.

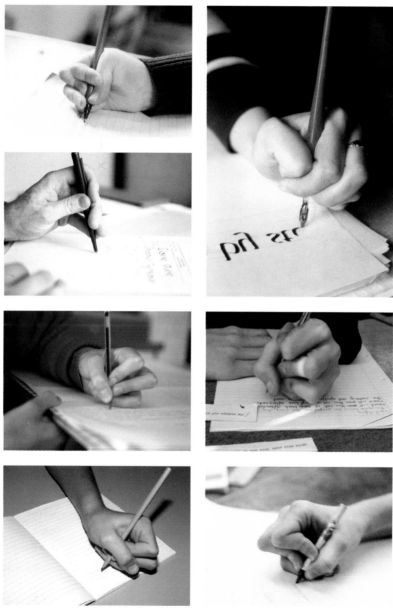

A selection of unconventional pen holds. All the writers proclaimed that they worked perfectly well for them, although some look as if they might cause significant pain if used for any length of time.

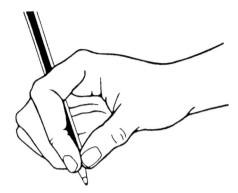

Three illustrations of an excellent alternative pen hold that uses a different set of muscles and is excellent for helping alleviate pain. Below, an illustration form Callewaert's *Graphologie et Physiologie de l' Ecriture* The artist, Eugene Delacroix, and his method of holding a quill, reproduced from a French banknote.x

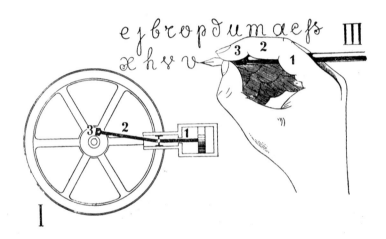

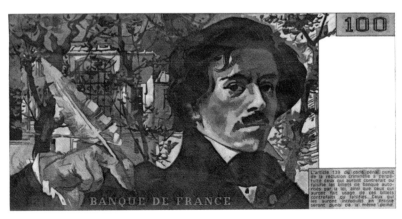

Everyone recognises the convenience and the advantages of the Biro and the plethora of modern writing implements. However, there is one problem. If you observe them closely, their various points all work best at different angles from a traditional fountain pen nib or a pencil.

Infants may well start mark-making today with a felt tipped pen, rather than the traditional coloured pencil. It is fun and colourful but differs in one important factor. It works best when it is held nearly upright, and the older the implement, and the more worn the point, the more upright it must be. To get an implement more upright the pressures from your fingers must alter. Try it. Either you have to press harder with your index finger perhaps taking your thumb out of action or you need to press harder with your thumb. That usually means that it comes across the top of the pen taking over from the index finger. That is just the beginning. All kinds of individual adjustments can follow.

Once an unconventional hold gets automated it is progressively hard to alter, more in later life when a Biro or other modern pen is used. Then what to do? It is so easy for well-intentioned people to interfere. Many writers, however, have found a perfectly comfortable and practical (though not very attractive) unconventional way of holding their pen. Unless there is very strong motivation it is hard to change. Sadly the best motivation is pain. Even then it is advisable not to impose your ideas but to let writers experiment (with a bit of help) to find a solution for their own hand. Remember their hand may be different to yours.

It is not just a matter of thinking of the hand and pen in isolation. Even the way your wrist works affects your writing. If you naturally hold your hand slightly on edge your writing may be narrow and slanting. If your hand is naturally flattened (pronated,

which seems much more common today) then your writing is inclined to be rounder and that is why many children who were made to learn italic, whose teachers did not appreciate this, found it so hard.

And it does not stop there. How you sit might affect how your hand can perform, and where you place your paper as well. Let me give you a couple of examples. A teenager, coming up to examination time had stopped writing altogether because it was so painful. Amazingly, no one had ever noticed that she sat sideways on to her desk instead of straight forward like everyone else. That meant that she was writing up and down the page instead of across it. This put intolerable strain on her arm, wrist and hand. Her story was that she was always too tall in primary school to get her feet under the table so had started sitting sideways – and never changed. How is that as an example of motor programming? It only took five minutes to solve that problem, but it highlights the lack of common sense on the part of teachers or therapists in ignoring such matters.

Next consider paper position. Traditionally people were taught to sit up straight and put the paper straight in front of them. Of course in those days it was all right handers, the left hand was not permitted. Now it is preferable to say: 'Put your paper to the side of the hand that writes'. It reminds me of a hospital patient in his twenties who developed a serious problem with his right hand. He tried to write with his left hand but gave up and concluded that there must be something wrong with that too. All that was wrong was that he never altered his paper from his right side over to his left. He was hunched over the paper with his writing arm extended across his body in a way that made the act too painful. That also took only five minutes to solve.

So, in the act of writing the three factors – penhold, posture and paper position – need to be considered. Ignoring them can cause the kind of pain and difficulties that can result in writer's cramp and might make you give up writing altogether.

The everyday handwriting of Victorian tradesmen might be thought of as calligraphy today.

Handwriting is the mark of a pen on paper.

Have you ever found how different it feels to write with another kind of pen, or noticed the difference, for better or worse, that it makes to your writing? Many people feel that a fountain pen is still the ideal writing implement, and it probably is for them. Italic writers need their broad-edged nibs, others find the flow and sensitivity of a really good fountain pen irresistible. Some people that I have met are even motivated by the prestige of using an expensive pen and how it impresses their clients. However, I worry when I hear that they are imposed on a whole school.

The writer needs both the nib and handle of the implement to suit their hand and their writing. As many people like a slim implement as like a fat one. In a specialist pen shop you get the kind of service that lets you try out their pens to see what feels right to hold and if the nib suits your script (and your budget). Less expensive pens are sold in bubble wrapping so the buyer has no chance of trying them out. A grandmother's expensive birthday gift might be counterproductive and not at all suitable for the recipient.

It is all back to understanding that people's hands differ, some large, some small, some fingers either extra long or short, or it may just come down to personal preference. That applies to all pens not just fountain pens. I have disproved many times over the flawed so-called research that proclaimed that children's small hands required fat pens and pencils. Anyhow there is nothing wrong with having a variety of writing implements in the classroom or office, suited to the occasion from a quick note while travelling, or to an important missive to a client or employer.

Now back to modern writing implements. Nicolete Gray

Right: An illustration of the school '230' BiC pen from an undated teachers booklet *Handwriting with the Ball Pen* issued by Biro Swan Limited.

Centre: 'A ball-point pen can follow all the line movements shown here.' An illustration from a report on the teaching of handwriting ATypI 1976.

Below: Nicolete Gray's flowing alphabet based on this concept.

a b c d e f g h i j k l m n o p q r s t
u v w x y z ai ay aw oo ou ee ea ue
gh th sc ph kn qu wr ing ed er est
A B C D E F G H I J K L M N O P Q R
S T U V W X Y Z 1 2 3 4 5 6 7 8 9

explained, in great detail and far better than I could do, in *The Times* (3.12.1980): 'From the point of view of the writer these new pens have two primary characteristics: the writing point whether metal or plastic, is held by a housing beyond which it has a limited contoured projection. Second alteration in line width (which obviously increases the aesthetic interest in handwriting) is obtained by pressure, not by stroke direction as with the broad-nibbed pen.' She then explained how it is these characteristics that require the modern pens to have a more vertical angle than traditional on essaying: 'The angle at which Parker tests fountain pens is 45; for ball points it is 70.' She added that this meant that the tradition penhold taught to children in school ought to be changed because writing at an incorrect angle is both inefficient and foolish.

Nicolete Gray went much further than that. She designed a new writing model for adults learning to rewrite as well as children, to take advantage of the way ballpoint pens could write both backwards and upwards as well as forward.

Handwriting is a visible trace of history, and of human development at the same time.

Handwriting reflects history as well as records it. I do not intend to write a detailed history, there are far too many good, scholarly books already. I only want to show briefly how it reflected and affected society and probably still will do in the future. Writing, as different from various iconic and pictorial forms of communication, which date back to the Stone Age, probably

started some 5000 years ago in the Middle East. When humans began gathering in communities and began to trade, probably farmers or merchants needed to record their crops. They used whatever materials were easily available – clay and the resulting cuneiform characters were formed by wedge-shaped sticks. Later came hieroglyphics in the Nile delta, making use of reed pens and papyrus. We all know about the complex and beautiful hieroglyphics, but there were two more levels of writing, hieratic and demotic. Writing then was the task of highly skilled but also quite powerful members of society who could be scribes or priests. That was still evident almost up to present day in some developing countries where the village scribe made his living by writing letters for an illiterate population.

Egypt showed, with their demotic forms, that writing was becoming more widespread and available to a slightly lower echelon of the population. Think of that in terms of education. By the time of the Roman Empire we have records of soldiers guarding Hadrian's Wall writing to their families and friends.

Next consider medieval monks spreading Christianity using goose, swan or other bird feathers as quills to write on beautifully decorated vellum – animal skins. Move forward to Europe in perhaps the sixteenth century, you have writing masters teaching the nobility and their families, showing that the ability to write, and to write well, was a mark of an educated person. The printing press was beginning to take over the burden from scribes so books could begin to proliferate, and increase the spread of education. Mass education in Great Britain and much of the developed world in the nineteenth century was the next step. The written word aided, to a certain extent, the Industrial Revolution. Legions of lowly paid scribes toiled away to keep

business of all kinds going. It was an essential job but no longer a prestige occupation.

Funnily enough, it is reported that in some circles it was no longer considered important to write well. Quite the opposite; that might give the impression that certain rich and pompous people could not afford a personal secretary or scribe. We all know what has been happening in recent years, the decline in the standards and teaching of the subject. What now?

Handwriting is redundant.

The demise of handwriting has been reported several times in the past. First when printing was invented, and again with the advent of the typewriter. Today the only way of ensuring that it ceases to exist is to stop teaching it. We cannot deny that the usage of handwriting is rapidly declining with the proliferation of technology. Whatever laws are brought in, such as those already in some states in the USA, I feel that many adults will still wish to be able to write, and that their children should be taught. Maybe we will end up with a two-tier society, with those who can only use the keyboard or some other form of digital technology, and those who possess both skills. When something ceases to become a necessity it may still be desirable, even covetable. Things tend to go in cycles so maybe written script will once again be treasured as an art form. Who can tell? We might even find, in the future when electricity may become so expensive, that the hand written mark may once again seem expedient.

There is one more thing to consider. With the gradual decrease in the use of handwriting we will miss the archives of written

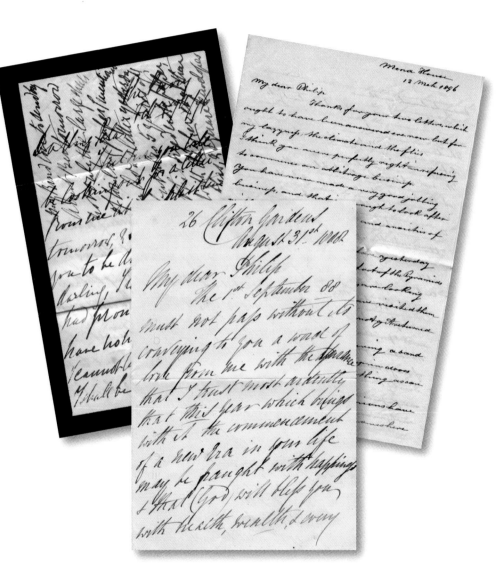

The scripts, as well as the content of letters from our ancestors, bring them back to life. Examples from *Keeping Chronicles, Preserving History Through Written Memorabilia*, Sassoon, 2010.

memorabilia that have illuminated the past for historians and families alike. Faded printouts, and stored emails can hardly be valued in the same way as our ancestor's letters that bring them back via the imprint of their hands and the force of their characters through their written trace.

Over the years I had amassed quite a collection of examples from all over the world, including school books, cookery books, diaries, etc. Because no one else was particularly interested, I inherited all the family letters and documents that my father and grandfather had preserved. Then, an old friend who lived to the age of ninety-nine left me her scrapbooks of written and printed memorabilia that covered much of the twentieth century. She also had given me her childish diary written in the First World War. Eventually I started to look at the contents not just the scripts that coloured this whole collection, and I decided to write a book on the importance of preserving written memorabilia for family reasons, and for the sake of local or national history. I called it *Keeping Chronicles, Preserving History Through Written Memorabilia*. As a result I was sometimes asked to give talks; nothing special, just to Women's Institutes and local history groups. I always asked people to bring in any written memorabilia they had at home, to make the talk more relevant. It is extraordinary what has turned up: Victorian adventurers' letters; war diaries from the Boer War and much more. They should have been in museums, passed on to the next generation or even published, rather than lying neglected in dusty attics. Then there was too often someone nearly in tears, relating how they had just consigned all their ancestors' letters and documents to the bonfire. Family history can disappear in a few unguarded moments.

The Society for Italic Handwriting

Italic handwriting is a simple, modern and elegant way to write. It is simple enough to be taught to young children, and modern enough for the needs of to-day. At the same time, its elegant letter-forms offer the pleasures of craftsmanship to the discriminating writer.

The aims of the Society are to foster the use of the italic hand in schools and outside, and to provide a focus for those who share this common interest. It holds meetings, arranges handwriting competitions and courses of instruction, mounts exhibitions & publishes a Journal, which comes out at least once a year, as well as regular bulletins.

Membership of the Society is open to anyone who wishes to join. You can become a member either by taking out an annual subscription or by signing a covenant which runs for a number of years. You will find overleaf an application form for the annual subscription, with details concerning the rates payable and method of payment. There is a separate leaflet about covenanting. Corporate members, such as firms and schools, receive five copies of the Society's Journal and bulletins.

An information sheet from The Society for Italic
Handwriting, dating from about the 1960s.

Handwriting can be beautiful but is it then calligraphy?

As that old saying goes: 'Beauty is in the eyes of the beholder'. The term calligraphy just translates as beautiful writing, but that is not enough, we need to try and find clearer definitions. There are differences of opinion on the subject between different professionals and individuals within these professions. For instance, the Society for Italic Handwriting is adamant that it represents handwriting whereas many people would consider what the members are promoting is calligraphy. Several years ago I asked some colleagues for their suggestions. One, who had a natural italic hand, said: 'It depends on the skill of the writer, and the amount of effort put into it whether it should be called handwriting or calligraphy.' Another said that it is calligraphy if the writer means it to be, and a third, when pushed, said it is a matter of art or utility. He pointed out the difference between cursive as handwriting and the formal hands that constitute calligraphy.

If you show one person a medieval manuscript he or she might enthuse about the wondrous illumination, thinking of that as calligraphy, paying no attention to the text. While the next person would be perusing the beautiful, uniform letterforms in detail, a third would scrutinise the handwritten notes that are often added later on in an impeccable hand of the next century. We may marvel at the copperplate script of the nineteenth century, not necessarily even in a prestigious document but a simple tradesman's bill. That would constitute calligraphy in many people's eyes today, but was everyday handwriting then.

So what might be beautiful to any particular individual? It might well be a carefully preserved letter from a long departed

grandparent, or even older ancestor, with the additional emotional impact of the content. This might well feel more beautiful than a rather contrived script trying to be perfect. To me a natural, flowing script of any style, not only italic, can be beautiful. I treasure many examples of colleague's letters, and even hesitate to get rid of their envelopes. Their beautiful Christmas cards cross the boundary between beautiful handwriting and calligraphy.

In the end it is up to you what you find beautiful and what you call it.

Ann Hechle, one of our most celebrated calligraphers, wrote something important in the 25th annual yearbook of the *Letter Exchange*. It perfectly links the first two parts of this book:

*'**Why write?** – is indeed a question we might ask ourselves. Now in the 21st century this has become a pertinent question – and a challenging one. What have we forfeited in the loss of the act of writing? Perhaps it is this: when we write we are – literally – in touch with the mark, the word. This feels powerful, as it is in doing that we understand – on a deeper than thinking level.*

Because we create these marks, stroke by stroke, letter by letter, we somehow enact the shapes and letterforms, gathering in subconscious thoughts and feelings. Thus by the touch of a pen on paper many level of feelings are captured and brought together. So this simple physical act can link and integrate the most practical, the most physical action with the most philosophical thought. It links our inner and outer lives and our sensual and emotional and intellectual worlds: Hand, Heart and Head. But also - and this is crucially important – each stroke of the pen carries the unique signature of a person, so the connecting thread that unites the levels is particular: significant to each individual's work and life.'

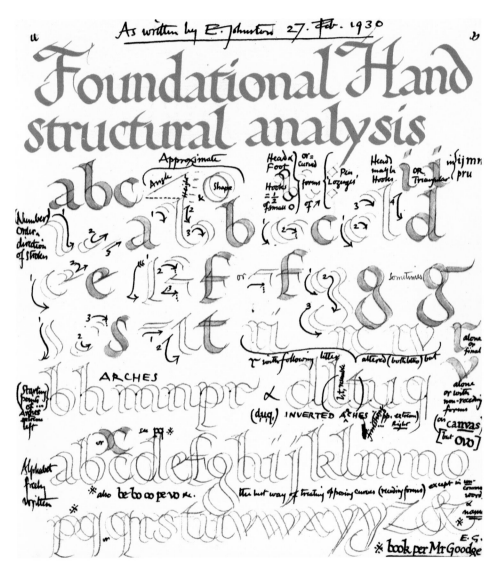

A blackboard lesson by Edward Johnston. Reproduced from *The Craft of Calligraphy*, by Dorothy Mahoney. Opposite: Some copperplate calligraphy by Paul Antonio.

Part 2

Calligraphy and Lettering

Calligraphy or formal lettering has frequently been the start for those whose interest in letterforms has been raised in some way. A pen, a quill, even a double pencil starts you on a study that can last a lifetime. Other people come to the skill through the study of ancient documents, where what is now termed calligraphy was the contemporary form of written communication, whether for a scribe or a lawyer. Many people have been directly influenced by more recent masters and their work, such as Edward Johnston, who reawakened the interest in the subject in the early twentieth century, Eric Gill, or later exponents such as Herman Zapf.

There are differences between the West and the other great cultures that have long had a calligraphic tradition such as Islam, and China, on these matters. I treasure a piece of Chinese writing, given to me years ago by an elderly man. He translated what he had written as: 'Calligraphy is the mirror of the mind'. I used that as an illustration when I gave a presentation at a conference of psychologists in Brussels many years ago. I called my paper *The Psychology of Western Calligraphy*. To show how little some of the participants understood what I was talking about, a prominent psychologist stood up afterwards and said this: 'Rosemary, don't tell me that you can express emotion through letters.'

I had to be a bit tactful there, but have expanded in my book *The Art and Science of Handwriting* where I reproduced the

'Calligraphy is the mirror of the mind' written by a Chinese calligrapher.

paper saying: 'Why should it be so difficult to understand that calligraphy, whether formally or informally written, should not show emotion via the hand to the paper? Why should it be incomprehensible that the writer in some circumstance, or in this case the scribe, should not consciously or unconsciously be affected by the meaning of the words that are being written or the mood of a particular piece of work?'

It is remarks like this that have prompted me to write this book. They make me realize how great is the gulf between those with an understanding of letterforms, and those without. For those involved in letterforms their field is as creative as sculpture is to a sculptor. The form and line of a letter is as sensitive and expressive as the line quality in a drawing and as individual as the interpretation of colour and light are to a painter.

Paul Antonio is a versatile and prolific calligrapher. He has a natural copperplate script that he uses extensively in his professional work. Having studied manuscript history he is able to exploit this research to create an expansive range of historical hands to compliment his studio work. Paul confessed upon leaving art school his focus was on historical scripts and he was fearful of modern takes on them. It was only though years of use that he got comfortable with the historical hands to then design modern calligraphic ones to amplify the scripts on offer in the studio.

He has also studied Archaeological Illustration and has done illustration work for the Metropolitan Museum of Art where he was asked to go out to Egypt to copy Hieroglyphs for their records. He also does this for the Petrie Museum of Egyptian Archaeology.

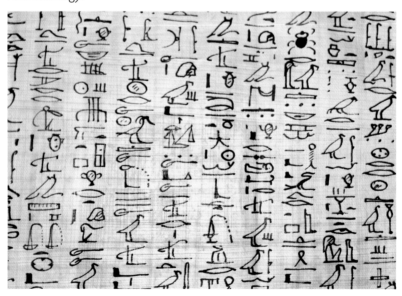

Designs for wedding stationery by Paul Antonio.

MR AND MRS MICHAEL WHORISKEY

REQUEST THE PLEASURE OF

YOUR COMPANY AT THE MARRIAGE

OF THEIR DAUGHTER

Kelly Maria

TO

Claus Gram Mikkelsen

AT

THE CHURCH OF

THE IMMACULATE CONCEPTION

FARM STREET, MAYFAIR

LONDON · W1K 3AH

ON SATURDAY 16TH MARCH 2013

AT FOUR O'CLOCK

AND AFTERWARDS AT

HARRY'S BAR, MAYFAIR

R.S.V.P
ON ENCLOSED CARD

DRESS:
LOUNGE SUITS

THE MARRIAGE OF

Claus and Kelly Maria

SATURDAY 16TH MARCH 2013

N A M E

☐ ACCEPTS WITH PLEASURE ☐ DECLINES WITH REGRET

PLEASE INFORM US IF YOU HAVE ANY ALLERGIES OR SPECIAL DIETARY REQUIREMENTS

THE FAVOUR OF YOUR REPLY IS REQUESTED BY 15TH FEBRUARY 2013

We would be delighted for you to join us

N A M E

☐ *We are / I am delighted to accept your invitation*

☐ *We / I require the accommodation reserved*

☐ *We / I regrettably decline*

PLEASE LET US KNOW OF SPECIAL DIETARY REQUIREMENTS

THE FAVOUR OF YOUR REPLY IS REQUESTED BY 15TH FEBRUARY 2013

THIS IS A SAMPLE OF MY PAUL

One of his projects is designing very special wedding stationery. Of this he says to the couples: 'I design this not for your guests but for you. The work is about making sure that whoever sees it will see it for what it is, a thing of beauty, something that has a purpose - both information and art.'

He says: 'My work is about how words end up on a surface; how they move from the mind or the mouth and leave an impression, either in or on a surface. Many things come into play here – what you are writing with (the pen, reed, brush or stylus), what you are writing in (the ink or pigment) and what you are writing on (paper, papyrus, clay). This is how the technology works together.'

Other things have to be taken into consideration, which I call the secondary technology, like desks, writing pads, chairs and their heights. But I have come to realise there is a much subtler interaction that affects the execution of the work and that has to do with what happens inside the individual. Breathing, internal calmness, rhythm (both internal and external) affects the delicacy and movement of the script. How it dances across a page! How marks are made and how in making them they combine to form the things we use as letters.

It is from the above that I draw my sensibility of lettering. Lightness of touch and letting the nib interact with the paper is key for me. For me it is about the paper coming to meet the nib and not the other way around and this is what allows the line to dance across the surface.

Understand the body is equally important – how to sit in the

ANTONIO SCRIBE SMALL CAPS

chair – are you using your fingers or wrist or if a big capital with flourishes, a whole arm movement?

The minutiae of what is happening inside the letters and between them I find fascinating; it is not what you write it is invariably what you don't write that is most important! The spaces between the letters and the spaces between the lines is what gives balance.

When I started training as what was then probably called a scribe, that craft and the possibility of practising it were markedly different from today. There were numerous opportunities for memorial books after the war, notices in cathedrals were still beautifully hand-done, and it was quite usual for work to be commissioned for personal presentations too. Of course some of this work still goes on. There is the work of heralds, and there are occasional loyal addresses to the Queen and civic jobs, even the intermittant memorial book.

One of these is a book of remembrance created for Great Ormond Street Hospital. It records the name of every child who has died there. This important commission was undertaken by Patricia Lovett nearly twenty years ago, and to underline the commitment and responsibility involved in this work, she still updates it every year. She explains what this means to the parents, the comfort that they gain from having their child remembered not only in the family, and the significance to them of having a permanent memorial to their son or daughter. I have reproduced here the card that is sent to parents once their child's name has been entered into the Book of Remembrance. As it

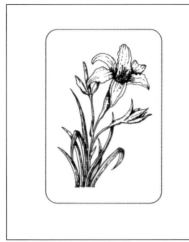

The card sent to bereaved relatives whose child's name is recorded in Great Ormond Street Hospital's memorial book, designed and lettered by Patricia Lovett.

It is not growing like a tree
In bulk, doth make man better be:
Or standing long an oak, three hundred year,
To fall a log at last, dry, bald, and sere:
A LILY OF A DAY
IS FAIRER FAR IN MAY
Although it fall and die that night,
It was the plant and flower of light,
In small proportions we just beauty see,
And in short measures life may perfect be.

Your child's name
has now been written in the
Book of Remembrance
which you may see
in the Foyer of St Christopher's Chapel,
at Great Ormond Street Hospital

THIS VERSE FROM A POEM BY BEN JONSON (1573–1637)
IS WRITTEN AT THE FRONT OF THE BOOK OF REMEMBRANCE

The heading to the poem above that I lettered for a bereaved family several years earlier in a very different style.

happens, some years earlier, I had used the same poem to letter a memorial piece for a bereaved parent. They illustrate two very different styles.

The change in the work of those involved in the craft is mirrored in the terminology – changing from scribe to letterer to calligrapher. Perhaps it is a consequence of so few really accomplished calligraphers, that much of the their work is for exhibition purposes today.

Izzy Pludwinski's formal training as a calligrapher took place at the Roehampton Institute in London with Ann Camp. He now lives in Israel. So much has been written over the years about calligraphy, but what Izzy has written in his introduction to his 2012 book *Mastering Hebrew Calligraphy* strikes a particular chord. He writes: 'In our modern age, it is legitimate to ask why bother writing letters by hand at all when one can use the computer to 'write' with an almost infinite variety of fonts?'

To the uninitiated, calligraphy can appear to be nothing more than a quaint, outdated hobby. In response to this, I offer a few thoughts.

First, on the level of experience. As a craft, there is a simple, primal pleasure to be had in the act of making something with one's own hands using materials – things of the material world, tangible materials that arouse the senses. The smell of ink, the look and feel of velvety parchment or a beautiful handmade paper, the sound of the pen swooshing in a flourish. All this is absent in the sterile word of the computer mouse and monitor. To create something unique (and what can be more unique than your own handwriting?), something that bears the stamp of one's own personality, something that cannot be exactly duplicated by anyone else on earth (including ourselves!) is an experience

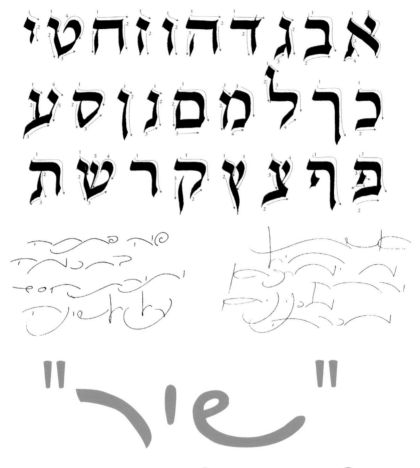

An alphabet of a Hebrew Varied Foundational Script, by Izzy Pludwinski.
In a search for more expressive forms, just playing with Hebrew letter forms
eventually led to his digital font, Shir.

of everlasting value, especially in our digital, everything-is-replicable age.'

There is another change that has come about, and that is exciting. As Izzy Pludwinski puts it: 'Calligraphy today is an exciting art form as well as a craft. The relationship of calligrapher to text is much less obvious than in the past. Lettering art can have many different purposes and the modern calligrapher/artist can use letters in forms that range from the formal and clearly legible to the wildly expressive and abstract. The sky has become the limit for the calligraphers.'

It is almost impossible to describe when calligraphy becomes lettering either in personal or professional terms.

Twenty years ago, not long out of art college, Rachel Yallop wrote a book called *Creative Calligraphy*, and that was how she would then have described herself. She now calls her work, illustrated on p62, that of a lettering designer. The book is ideal for encouraging young designers to experiment with letterforms and deserves to be re-published. I find that in the introduction I had written: 'The choice is yours, to express your own ideas through letters in the same way as you do through words.'

The pen is the start for so many careers in different fields of letterforms. Take Tim Donaldson; he taught himself to letter during his teenage years, from a book by Hermann Zapf that he found in his local public library. He diversified in all directions and now finds himself a professor of typography. I like the term he uses to describe himself – a letterworker. This might be used to describe many of us. I also like his comment in the introduction to his book *Shape for Sounds:* 'Typography is the engine of graphic design, and writing is the fuel.' It seems to knit together the different sections of this book.

1

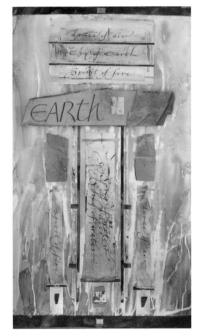

2

3

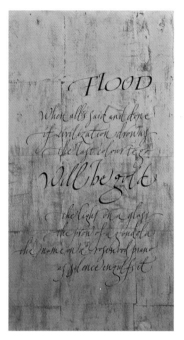

4

Examples of Gaynor Goffe's calligraphy.

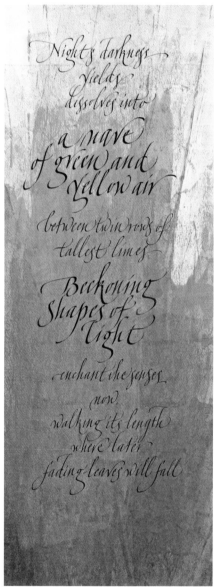

5

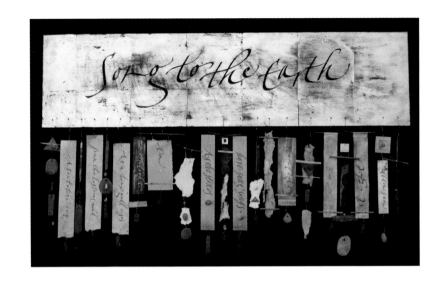

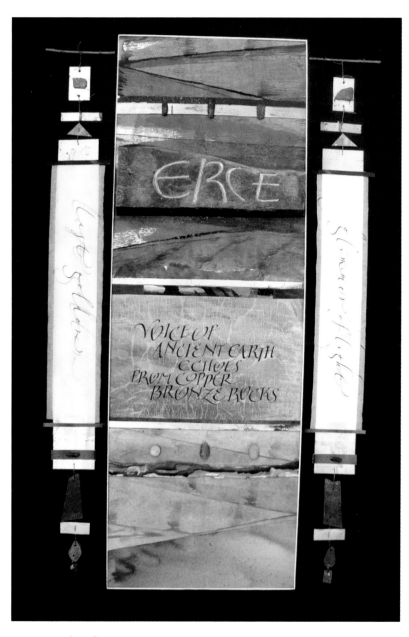

More examples of Gaynor
Goffe's calligraphic work.

The theme of this spread is concerned with the more spiritual uses of calligraphy. Both pieces appeared in *Holy Writ, Modern Jewish, Christian & Islamic Calligraphy* an exhibition at Lichfield Cathedral in 2014. In the introduction to this exhibition, Peter Halliday writes: 'This brings together the words of the three Abrahamic religions, Judaism Christianity and Islam... Each religion has always used the written word, embellished by calligraphers, illuminators and painters as an essential vehicle for the dissemination and recording of the faith. Modern creative calligraphy continues the tradition.'

The central idea in this piece by Izzy Pludwinski is that of renewal. The Chassidic text in the background, based on various texts from the Scriptures sees freedom from slavery as expressed through the paradigm of the exodus from Egypt.

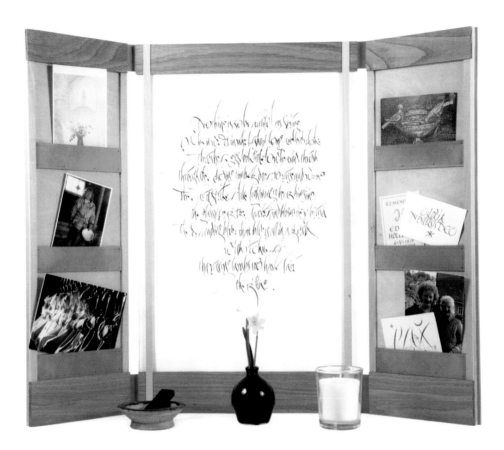

A Domestic Shrine.

Ewan Clayton wrote: 'This domestic shrine is intended to act as a contemplative space within a home.' You can use the pockets for photographs or momentos of those we want to keep in mind. The central panels are removable, up to four alternatives can be stored behind each other in the shrine. These panels can relate to the liturgical seasons or particular significant festivals; they may refer to traditional moments in life (birth, death or marriage) or a quality that the user wants to bear in mind. They can become focal points for everyday liturgies of lighting a candle or a stick of incense, they can be enlivened with the placement of a small vase of flowers, a twig or blossom.

Classical packaging from the 1950s showing how beautiful lettering on every day objects such as this writing pad and Knight's Castile soap, designed by Jeffery Matthews, can lift a product to a higher level.

Part 3

Packaging, Advertising, Logos, Book Jackets, etc.

If you want to discover how letterforms and design can influence the way people spend their money, a job as a packaging designer is a good place to start. Their purpose is to design something that presents a product in the best possible way to attract customers when it is on display. When I started at a works studio it was just before the coronation. Every product, even sixpenny toffee bars, had to have a royal appearance. My traditional pen lettering and things like heraldry were in great demand. Perhaps that was why

I had been offered the job. Very soon quite other skills were needed.

The factory produced materials for all kinds of food, for instance bread wrappers, biscuits and confectionery, as well as soaps and other toiletries and wrappers for many diverse products. It was long before computers or even photocopiers, so designers had to initiate any letterforms needed other than typesetting for such things as ingredient panels etc. We sometimes drew our own variations of interesting display typefaces, particularly ones gleaned from continental design journals. In those days, however, we all knew how to draw and produce original letters that brought out the character of the product. Of course colour, and perhaps drawings or photographs combined with the lettering were used to influence the customer, but not nearly as much as they are used today. Colour separation was still an expensive item so the kind of modern, multi-coloured packs were few and far between, for better or worse. It was the lettering that was most important. We used it every day, sinking our imaginations into the subject or object to get the feel of a product and how to project it.

A design from the 1950s.

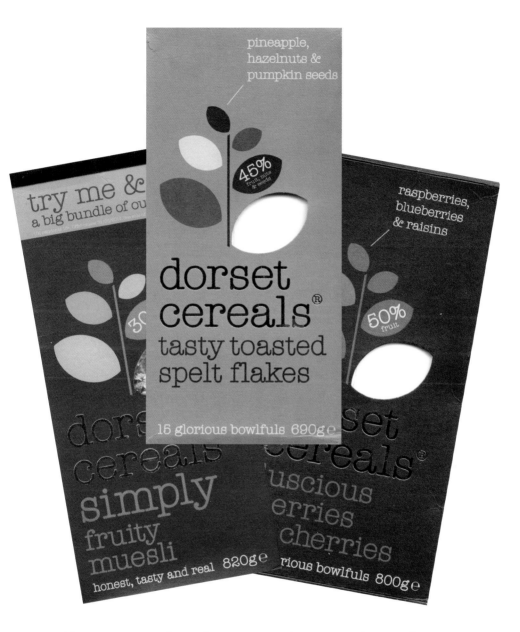

These contemporary designs from Dorset Cereals® are outstanding examples that would catch the eye of any browsing shopper to their product on today's supermarket shelves, and express the quality of the product.

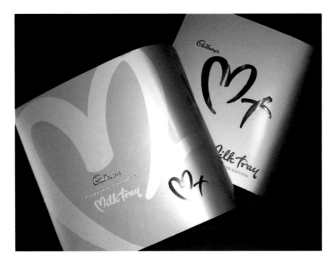

Rachel Yallop's packaging designs stand out on supermarket shelves with their individuality of letterforms characterising the products.

I suppose it could sometimes be considered leading the purchaser astray, or almost deceiving them – and of course it still is. The retailer or producer was and still is the designer's client. It was fun. Sometimes clients needed logos designed, sometimes help in how to display their products to best advantage on the shelves. We learned things that perhaps we were not meant to, such as how the most expensive London stores purchased their confectionery from the cheapest manufacturer. Then it was our job to design opulent wrappers to make the product look extravagant.

Only a few mangled bits of my own, or my studio's work of 50 years ago remains, pasted into my scrapbooks, but they illustrate how simply and expressively the letters, whether drawn or typographic, show how styles have changed. Look at Sainsbury's sample on page 60. They project quite a different image of the company to the way their present day supermarket packs do.

Rachel Yallop has provided some examples of how she uses what she terms 'creative calligraphy' when designing packaging, advertising or logos. Designers like her are few and far between.

Rachel has sent two recent examples. As she says: 'The Milk Tray design was based on an M and a T but at the same time needed to look like a heart and a kiss. I seem to remember it was launched for a Valentine's Day. There was also a chocolate with the logo on it. I did the original artwork with a round brush.'

'The Farmers' Market soups range had many flavours – I think I must have done 12 to 16 variations. The idea was for the lettering to look as if it had been written in chalk on a black board. I actually used a folded ruling pen for the lettering and the original artwork was solid black. The designers then did something to it on the computer to give it a chalky, textured look.'

Blindsight

More of Rachel's work, some finished logos and some quickly sketched ideas at the early stages of development.

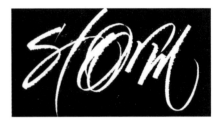

storm

Lyoness

swish

Organic

Rachel also mentioned what a problem it can be working with graphic designers who know nothing about lettering. She said: 'Being a long time since I was at art college or taught design, so I am not sure what they learn at lettering now. Communicating what they want me to do can be frustrating at times as they do not know the basic terms like 'downstroke' or 'counter' or anything about the process of how letters are made. However, we get there in the end'.

She explained the process of commissioning and working through a job today.

1 The graphic designer will telephone or email me with the general concept of the job. These designers work for major design consultants who often specialise in packaging design or brands.

2 Sometimes they have worked on the lettering design already (usually not good!) and they want me to redraw the word or name. On other occasions they have put together a sheet of pieces of lettering that they like and then I create something to match or which has a flavour of their ideas.

3 When I have done a few drawings or written out the name in various ways, I scan and email them to the designer. I get feed back and re-work them, email again, and so on. I supply black and white finished artwork, ink on paper, which is scanned and emailed to the client – gone are the days of motorbike couriers collecting final artwork!'

ABCDEFG

Anna Ronchi is an Italian designer based in Milan. She tells how a few years ago she found all opportunities to do lettering for agencies dried up. 'Neither calligraphy nor lettering was needed as any number of digital fonts could do almost the same work much more cheaply. Around this time I began to feel that calligraphy had to be the opposite of typography: irregularity, expression, contrast were all aspects to be enhanced, while still maintaining the legibility that is so important in graphic design.' One project was to design labels for a brewery, with her partners in their studio – Ronchi, Tubaro and Thom. 'The names of the beer being very evocative for anyone living in Milan, we decided to illustrate their meaning with a symbol and text. For the packaging of a wine called Sasso Nero (Black Pebble), we decided to show what could be done with stone cutting. That's another discipline that is not practised in Italy.' What an impressive design these letterforms made.

There have been real problems putting together this section. While friends have provided examples of their work, there are great difficulties in getting permission from firms to reproduce contemporary examples of their logos or advertising. The complications of copyright law have made it impossible. Of course it would be fun to reproduce bad examples as well as good – but that would be even more impossible.

HIJKL

Etruria typeface designed by Anna Ronchi.

Labels for a brewery in Milan designed by the studio of Ronchi, Tubaro and Thom.

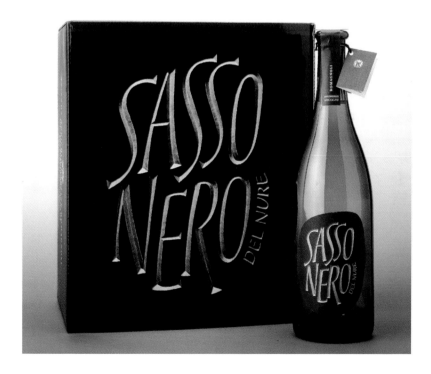

With huge budgets for advertising and packaging today it is perhaps inevitable that sometimes it becomes a matter of design by committee. A client will obviously consult with his colleagues, but it is a committee of designers to start with that many of us would deplore. A well-informed designer knowledgeable in both the needs of the client and the means of production would still be the most satisfactory situation. I am reminded of a drawing from the 1950s that I found in my scrapbook. I do not know where it came from or who drew it, so hope that I am not infringing on someone's copyright.

Now to an example of something familiar to us all – modern supermarket packaging and display. This seems to show that the designers, or the people who order designs, do not always project the right image. Most supermarkets today sell their own-brand products, and may also have developed a more superior range. Each level has different packaging designed to give off a different message, and they sell along with many other commercial products, again with their own distinctive packaging. Recently some supermarkets have launched an economy or value range. In my local supermarket these products sit discretely on the bottom shelves and their packaging is markedly different from the rest. It is plainer, somewhat cleaner and restful, and far less multicoloured than other packs. What message are the letterforms and design of this range giving out? Is it that the products are economical but good value therefore suitable for those with not much money? Or is it saying they are cheap and perhaps not very good quality so if you can afford it buy our more expensive range? Whatever the message was meant to say it has not always been interpreted correctly by everyone.

I had saved this cartoon, illustrating the disastrous results of committee interference in a design, for my scrap book, sometime in the 1950s. I did not note the artist at the time.

Out of interest I asked several people for their thoughts on this matter. Their answers varied from someone who really needs to be economical but answered: 'I would not be seen buying that cheap rubbish' to several people well able to buy the more expensive products who could not discern much difference between the value or economy range and any other and have been delighted not to be spending any more money than necessary – hardly what the supermarket wanted. Lastly, when questioned, a usually common sense elderly lady, answered: 'I never trust any of those own brand goods, and always go for familiar makes like Heinz.' The psychology behind packaging is complicated and not everyone gets it right.

A selection of Michael Harvey's book jackets reproduced from his 2012 book *Adventures with Letters.*

What else might have an effect on our choosing something? Book jackets reach out to tempt us in supermarkets, airports and elsewhere. Usually they are well illustrated and often highly coloured. Letterforms by themselves, however, can do just as well in expressing the subject and tone of a book. Look at these book jackets, the work of Michael Harvey, reproduced from his 2012 memoir *Adventures With Letters*. He was a man whose work spanned all aspects of letterforms. Examples of his typefaces appear in the next section and he was well known for his stone cut and carved work that adorns many cathedrals and other public buildings.

In his obituary, dated October 2013, Nicholas Barker wrote: 'He believed that the shape of letters should match the purpose to which they were put and what he carved or drew added his own conviction to the message that they conveyed.'

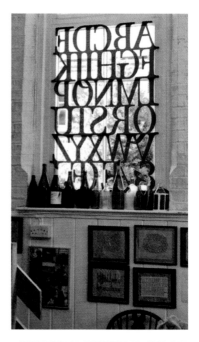

Top: One of David Kindersley's alphabets framed on a window of the workshop, and, below, another printed on his curtains.

TRUMPINGTON STREET

An example of David Kindersley's legible, elegant letterforms designed for road signs.

Letters can be so beautiful in themselves that they do not necessarily have to have any other purpose. The alphabets, overleaf, from David Kindersley's 1969 book *Variations on the Theme of Twenty-six Letters* show this. In addition these were developed into giant plastic alphabets, now in museums all over the world but also hung illuminated by the light in the Kindersley Workshop windows. Prints of them put lettering as an art form back onto our walls, and I even spotted some of them reproduced on curtain material in David's home. One of these alphabets was the inspiration for the famous gates of the British Library (see p100).

Another quite different aspect of his work was a commission from the Ministry of Transport to produce an alphabet that could be used whenever new road signs were needed. The results combined elegance with legibility. Then he devised a system of spacing that would work with any combination of letters and enabled unskilled workers to apply when casting or stamping them in relief. Once again this shows how impossible it is to place the work of these great letterers into separate categories.

We all deplore the lack of teaching of lettering skills that so depletes the store of original letterforms that would reflect today's culture. The few people still able to undertake such work are probably expensive, unlike the old days when there

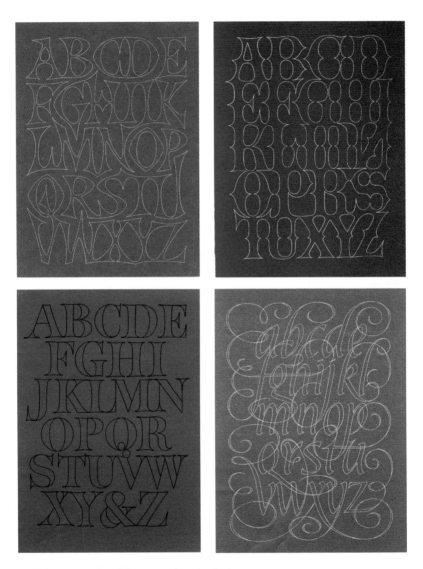

Alphabets reproduced from David Kindersley's 1969
book *Variations on the Theme of 26 Letters*.

were so many of us around. That is another deterrent to clients. Rachel Yallop, who still finds time in her busy life to teach lettering, underlines what a demanding skill it is saying: 'It takes time, energy and concentration to become proficient.' She describes how, only too often, her students watch her apparently effortlessly producing her beautiful letters and feel that it looks easy. They soon give up when they find out how hard it is. Another colleague who teaches says that she thinks they lack the confidence (as well as the knowledge) to tackle letters. That is certainly what I found when I ran a weekend course in Rome for young designers. I had to use devious techniques to get them to relax before they could produce some personal letterforms. That would be just the beginning, and I have no way of knowing whether any of them pursued further studies.

Recently a post-graduate student asked me for my views on the influence of both computers and smart phones and tablets on designers. What can one say? To condemn students as lazy because they are thrown back on easily available letters and images accessible at the touch of a button is not helpful. Where are the teachers who should be training and inspiring those students? How can young people find the time and enthusiasm that those of us who have spent our lives in letters all started with? So, progressively, designers are thrown back to depend on ready-designed typefaces. Even with the plethora of those available at the touch of a button, it is not the same. Original, innovative lettering is still vital today in developing a brand image or a logo. All we can hope is that these things come and go in cycles. Once a certain feeling of uniformity creeps in more imaginative work becomes valued and in demand once more.

It is interesting to note what that great letterer Percy Delf

Smith wrote, in 1946, of how he saw the future: 'Lettering is
a craft in what must be a unique position with respect to the
future, for three main reasons:

1 By far the major amount is required for peculiarly specific
 purposes; for these it cannot well be mass-produced.

2 It is an inevitable need of material, intellectual and spiritual
 life: it cannot be dispensed with or go out of fashion.

3 Though the technique appears relatively easy, the special
 kind of personal qualifications required for its sustained
 practice in a good form, limits the number of good
 practitioners. It is true that its practice does not offer the
 hope of very large rewards, a fact which may turn aside
 those who think on such matters.'

It does not seem that much has altered in the intervening years.

Surely no one could discard these beautiful Christmas cards with the rest of the decorations. Lida Cardozo Kindersley, left and Rachel Yallop, below.

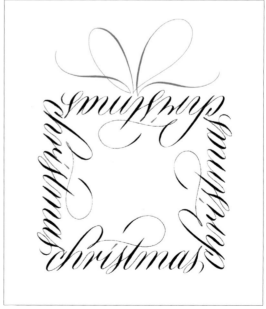

STEPHENSON BLAKE · SHEFFIELD
DISPLAY
S B
TYPES

TEA-CHEST: A VARIANT ON AN OLDER THEME: 48, 60, 72 pt.

TEA-CHEST
TEA-CHEST

CHISEL: AN ADAPTION OF AN EDWARDIAN DISPLAY TYPE: 48, 60, 72 pt.

CHISEL
chisel

Examples of display type faces from one of Stevenson Blake's catalogues from the mid 1950s.

Part 4

Type Design

Display types had always attracted me, ever since my days as a packaging designer. However, I had not paid much attention to text typefaces when I was younger, I am ashamed to say. I might notice that the layout and general appearance of certain books were more attractive but that was about all. Later I read a bit on the subject, and one book that left an impression on me was G.W. Ovink's 1938 work *Legibility, Atmosphere, Values and Forms of Printing Types*; it was that word 'atmosphere' that stuck in my memory. I had a friend who was aware of such things from a very

PLAYBILL: A VICTORIAN REVIVAL: 24, 36, 48, 72, 72 (Titling)

early age. He told me this story: a kindly relative once gave him a certain book as a present but he disliked the type so heartily (I think he said it was very bold) that he threw it back. Then I remember an elderly typographer saying that he could never countenance gothic typefaces as they reminded him of the posters in the stations along the line as his family fled from Nazi Germany. Later I was to find that children could discern and describe typefaces in terms such as friendly or cruel, whereas their teachers seemed unable to understand, as if age and saturation of print had stopped them noticing such things.

On a different level, think of newspapers. There is an obvious visual difference between tabloid newspapers and traditional broadsheets (not only the expectation of page three pictures). The message that the type and layout give out probably influences which one you would choose to pick up and buy without your even noticing the title.

Now back to my own interactions with type or typefaces. As I get older and my eyesight worsens, deciphering the phone book gets more difficult. Like most people I would have thought that it was mostly caused by the size of the type. I now know that a new typeface has been designed to help improve legibility (but because the size of the phone book has been reduced I cannot see much improvement). Previously I had not given too much thought about how typefaces might influence competent readers in the way of speed or comprehension. I am not so sure that even many of those involved in type design take that into consideration. I put it this way because most of my subsequent findings in this area have been because of common sense observations, not because of any special expertise. I never expected to have much to do with typography, much less to become a type designer.

Typefaces for children – and adults too

Forgive me if the next part concerns my own work, but it concerns how I found out how much difference a typeface and spacing could make to how an important section of the public – our children – could learn to read. It all happened by accident that I discovered how quite simple typographic factors affected children's ability to read and comprehend text. One day, in the early 1980s, while I was dealing with some handwriting problem or other, a glaring problem was brought to my notice. An observant special needs teacher said to me: 'Rosemary, you know all sorts of odd things' (that was obviously what she thought of letterforms).

What worried her was that her problem readers had no trouble with the first half dozen pages of the reading scheme they were using, but thereafter found things difficult. It was easy for me to see why this was happening. It was not necessary to have any particular typographic expertise. The first pages were not justified but afterwards the short lines of the book were all justified. Today, most people know the difference between justified text and unjustified text. In those days, before computers were in general use, it was not so. I explained that the even spacing in the first pages made it easy for the children to see where one word ended and the next began.

In unjustified text the right hand margin is uneven, but that is not going to worry children. The advice that is usually given is that short lines of relatively large print, as found in young children's book, should not be justified. We can all see what sometimes happens to the spacing of text in narrow columns in our newspapers. There are either huge, distracting spaces on one line, followed by everything cramped together on the next

where an extra word has been fitted in. As adults, we probably just take it in our stride (if we have no specific reading problems), and if we notice it at all, it is just a bit of an annoyance. Anyhow, that was what was happening in the pages of the second half of the reading book. Where an extra word had been fitted in I could spot such words as 'of the' looking like one word: 'ofthe'. It was no wonder that the poor children, who had enough problems already, could not decipher the text. With pages of books for adults, the result of justifying is nowhere near as apparent.

Babar made his home
in the old lady's house.
Every morning
they did their exercises together,
and then Babar had
his bath.

*Babar made his home
in the old lady's house.
Every morning
they did their exercises together,
and then Babar had
his bath.*

Pages from different editions of Laurent de Brunhoff's *The Story of Babar* first published in 1934. One uses a conventional typeface and the other a script usually found only in French language editions giving a quite different feeling to the story.

Smaller type results in many more words in a line and slight adjustments in the spacing usually sort things out without difficulty. It is left to the book designer to decide which method to use when setting type for a book, whether they want a neat right hand margin or more even spacing.

Anyhow this made me wonder what would be the optimum spacing required for those who found reading difficult, as well as for young readers in general. When I searched for information on spacing, I could not find anything useful, so I decided to do a bit of research myself. It should not be too difficult, I thought, as I was in and out of schools all the time.

Next it dawned on me that I would have to decide on which typeface to use when printing samples of differently spaced words. It was a real shock to find that no one had ever bothered to find out what might be best for children. Various adult 'experts' had voiced their own views, but no one had ever actually asked the children. I found this inexcusable.

Just out of interest, before starting my own enquiries I had a quick look at what kind of other letterforms had been used in children's books in the past before.

In my other work, dealing with handwriting problems, I had found that when treated as intelligent people, children could often explain what their handwriting problems were, when experts had so often misdiagnosed them. I was pretty sure that they would be able to indicate their spacing and even type preferences if they were given suitable alternatives to choose from. Four typefaces were chosen along with four different spacings. How was this to be tested? I have always been a bit sceptical about testing children in sort of laboratory situations. With such a sensitive matter as reading surely their teachers

All About the Night Before Christmas

'TWAS the night before
Christmas, and all
through the house

"Let her go! Let her go!"
said Rex, the black dog.

The tiger cubs
are playing.

Examples of the kind of letterforms in earlier children's reading books. In 1930, small print with wide word spacing; in 1950, a bold sans serif; and text from a page of a 1950 Ladybird publication.

in their own classroom would lead to more realistic results? This meant that I could not conduct a really scientific study as it had to be in school time, so I could not dictate exactly how thoroughly everything was done. I gave several schools, in various parts of the country, the material for testing and let them get on with it. In the end it was not the statistics that were so important, it was more the children's comments, carefully recorded by the teachers. They held the vital clues.

The results of the search for optimum spacing was not complex, but started to make me think a bit deeper. It was common sense really. What suited problem readers best turned out to be very widely spaced words, even a new line every time a new sentence began. All this, the children reported, annoyed good readers, whose reading and comprehension were disrupted by such wide spaces. Perhaps this would have implications for different levels of adult readers too – but this would have to wait, because what transpired from the four choices of typefaces was much more important.

The typefaces I chose for the project were Times Roman. I do not like it for children but experts assured me that it was the best. Times Italic, which I had heard some teachers of dyslexic children favoured was next, then a standard sans serif and a slanted one which seemed a good idea. Once the results were in (it all took nearly two years) the overall choice astonished me: Times Italic came first, then the slanting sans, then the regular upright sans and last of all Times Roman.

Why was Times Italic the favourite? Only the children could tell me. They said they liked what they called the 'flick up' and left me to find the reason why. The obvious thing to me was that some kind of 'lead out' from letters would bind them together as a word.

The trouble is that we do not know exactly how people, particularly beginners, actually read. Do they work words out letter-by-letter, thence to whole words, or do they recognise the shape of words as a whole pretty soon? It probably differs from one child or person to another. If word shape is important then what can a type designer do to help? It was a tempting problem – after all a designer is a problem solver and that is what I am.

The only thing to do was to design a typeface quite different from any in use with what I called exit strokes, and accentuating word shape first of all. If you look at almost all modern typefaces the ascending and descending strokes have become shortened over the years. This erodes the word shape and has come about because of the desire to squash as many lines of type into as small a space as possible in a page. So those strokes had to be lengthened slightly in my new design. What next? I felt that the letters should somehow have movement within them, the way the strokes in handwriting move. Then, perhaps most important of all, the font should look friendly, more accurately child-friendly, not menacing, not harsh or any of the words that the children had used to describe some of the typefaces that they had been shown.

Now I want to repeat something that was said to me some years later when I gave a presentation about my research, which demonstrates how little those in other fields understand our subject. I had just mentioned about this friendliness that had been designed into my font when someone in the audience piped up: 'Don't tell me that you can express an emotion such as friendliness in a typeface.'

Designers know that you can build an atmosphere of happiness, elegance or even vulgarity into a typeface, and this is

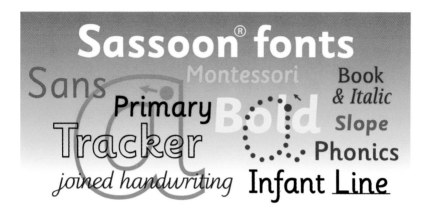

A selection of the fonts designed for educational purposes.

a positive act. That is what we do. Why should it be so hard to understand why someone cannot convey emotion via the hand to the paper whether calligraphically or through drawing up a type design?

Eventually Sassoon Primary Type was launched in the mid 1980s with the help of my colleague, Adrian Williams. The job of producing detailed drawings from my original sketches and then digitising it all is a complex and difficult job, way out of my experience and competence. Once a font is out in the open and on sale it can be used for any purpose the buyer wishes. It has been interesting to see some of the uses that a typeface that was designed for five-year-old kids, with definite juvenile vibes, has been put to. First of all it was meant as a font to make reading easier, but there were people who obviously felt this to be an unusual idea. I was asked to talk about all this at an international conference of a society concerned with writing and computers. It was quite near home and I chose to put up a

for the NHS to introduce free testing next April could lead to some eye problems like glaucoma and cataract going undetected. To arrange your free eye test call in at your local Dollond & Aitchison.

TIL FURTHER NOTICE. THIS DOES NOT AFFECT ARRANGEMENTS FOR CUSTOMERS ALREADY ENTITLED TO NHS FREE EYE TESTS.

Relax,

this cuppa's a natural!

Natureland are 100% natural fruit and herbal teas, with no artificial colours or flavours. Natureland tea is also caffeine free. So for a healthy alternative, relax with the fresh, clean flavour of Natureland.

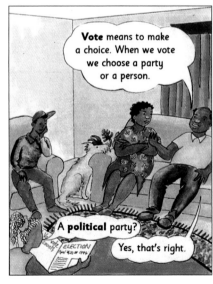

Some examples of different usages of the typefaces initially designed for children.

A new concept in beauty spa and pampering

Treat yourself to luxury massages; facials; body tanning; pedicures; manicures; reflexology and much more!

Relax yourself in the hands of our experienced staff, set in the beautiful surrounds of the vineyard.

With free parking; licensd bistro; exlusive wine shop; "Plantbase" with its exotic range of plants and the renowned "Swan at the Vineyard" restaurant and bar.

poster display rather than talk. When the participants, mostly American, came out of the lecture hall for their lunch, a large group stopped in front of my display and were heard to exclaim various versions of: 'We never thought typefaces were important or made any difference at all.'

Sitting quietly in a corner was someone who turned out to be a publisher. 'If they know so little about the importance of typography perhaps we ought to have a book on the subject,' he said. The result was two volumes called *Computers and Typography*. I did not know nearly enough to write a whole book on the subject so persuaded colleagues to contribute the majority of chapters. As a result I learned a lot more myself.

Just one more quote and then the discussion can move on from my work – but this can explain best how considering and researching the requirements of the reader had further implications. Somehow the method and design had been justified. One day a very respected colleague, a university lecturer, came up to me at a conference saying:

'I hope you do not shoot messengers but I tested some of my students on your primary typeface and I am sorry to say they found it patronising.' I was delighted. It proved just what I wanted. The juvenile vibes built in to the design to suit young children were discernable to adults and they were put off. What is more, he encouraged me to build the same principles of word shape and legibility into a couple of adult fonts. They work very well especially on computer screens where the need to cram so many lines of type into a small space is not particularly important.

Now my colleague Adrian Williams is extending the concept of child-friendly letterforms to other writing systems. First he had to ensure that he had included all the diacritical marks for

Sassoon Infant Pro
Regular, English

Sassoon Infant Pro
Bold, Greek reading
letterforms

Sassoon Infant Pro
Regular, Greek pre-
cursive letterforms

Segoe Print, Greek
reading letterforms

hope for unexpected

ελπίζεις το ανέλπιστο

ελϖίζεις το ανέλϖιστο

ελπίζεις το ανέλπιστο

Sassoon Infant Pro
Regular, English

Sassoon Infant Pro
Bold, Cyrillic reading
letterforms

Sassoon Infant Pro
Regular, Cyrillic pre-
cursive letterforms

Propisi, Cyrillic
cursive letterforms

Eat some tasty rolls

Съешьте же булок

Съешьте же булок

Съешьте же булок

every country using the Latin (Roman) letters in his international
font. Then he made specific packages for different groups of
countries such as Scandinavia, including Icelandic, with some
additional characters and diacritical marks. Some of the more
unusual ones are left out of other sets of letters. Then he started
on Cyrillic (for Russian, Ukrainian, Bulgarian, Serbian, Macedonian
and Belorussian).

It is interesting to note that we have had feedback concerning

older pupils and even adults with handwriting problems, saying that they did not like learning from an alphabet with such juvenile vibes. In consequence we have produced a more mature font for them for handwriting.

The Latin alphabet can be written by hand with links to join every letter, whereas Cyrillic cannot. Some letters are more akin to drawn shapes, while others have obviously calligraphic characteristics, making them not so easily written.

These present letterforms are intended for reading, So far the Cyrillic has found a usage as a reading font but it is hoped that one day this work will result in a simpler form for teaching Cyrillic handwriting. The present, traditional form is difficult for children to learn.

To influence the teaching of writing is likely to take a whole lot longer. The Greek will soon follow.

Icelandic Thorn and Eth

Caron or inverted circumflex.

Cyrillic

Greek

What about the work of professional type designers? How do their businesses work? How are they trained? Many but not all have a background of lettering. They seem to split their expert and time-consuming work several ways. Sometimes they can spot a gap in the market to create a novel typeface, sometimes they work on originating their own ideas then launching them on the market. Much of their time, however, must be spent on corporate commissions where they create bespoke fonts to suit their client's brands or concepts. In between they can alter and adapt standard fonts when asked.

There is another function that I hope will become more frequent where type designers are going out into the community to use their skills to solve very specific problems. This has resulted in typefaces designed to help those with special reading problems. Dr Rob Hillier developed a font for adult dyslexics that he called Sylexiad. It involved lengthy and thorough research with the problem readers, and formed the basis of his

abcdefghijklmnopqrstuvwxyz
ABCDEFGHIJKLMNOPQRSTUVWXYZ
0123456789&*@\:,$=!<>()%+?'";£.

abcdefghijklmnopqrstuvwxyz
ABCDEFGHIJKLMNOPQRSTUVWXYZ
0123456789&*@\:,$=!<>()%+?'";£.

Examples of Sylexiad, a typeface researched and designed for adult dyslexics by Rob Hillier.

PhD thesis. Then there is Fontsmith's FS Me which was produced for Mencap to help learning disabled readers.

Rob Hillier writes more on the researching and testing of fonts saying: 'With the exception of some notable examples, such as Sassoon Primary (designed for children), Tiresias InfoFont (designed for the visually impaired people) and Sylexiad (designed for adult dyslexic readers) it has always surprised me how so few typefaces have actually been developed, tested and designed for a specific and targeted audience.' I have to add that it does not surprise me when I remember how much time it took Rob and myself to do our research.

Rob continued: 'Most fonts designed today, I would argue, are the result of an intuitive design process which is often still based on old typographic rules of legibility and readability, many of which were established during the 19th century. If a typeface is ever tested for legibility, it is never during the design process but usually retrospective. By this I mean that the legibility tests are conducted after the typeface is designed. Consequently, the design, no matter how beautiful, elegant or indeed ugly it may be, was created as a result of the instinctive responses of the designer and not those of the potential reader.'

To this I would add that when I started to test for legibility I discovered that previous studies, such as they were, had depended on speed of reading. To me this muddled legibility with comprehension, and at my suggestion, future ones were designed using random common words that could really define what forms were most legible.

Rob finished this argument by saying: 'The democratisation of typography through digital software has provided typographic designers with the opportunity to truly target specific reader

FS Albert Light · 18pt

With a wide range of weights, Albert is a charismatic and truly versatile face, ideal for use everywhere from text to display.

FS Rufus Regular · 24pt

Wide, cheeky forms with curious ink-traps and plenty of discretionary ligatures...

Jason Smith's typefaces Albert and Rufus.

groups with specific reader requirements. I feel that the potential for typographic designers to help ameliorate reading difficulties is a yet still untapped proposition. The opportunity to develop typographic design in tandem with the testing process should be greatly encouraged in order to fulfil this potential.'

It need not all be too serious. Jason Smith has a relaxed and original attitude to his designs. He described, in an article in *Forum, Journal of the Letter Exchange*, that his fonts have names and personalities saying: 'This is Albert, a charismatic, charming chap, and this is Rufus, a slightly odd humanitarian.' Asked if he thought people judged him on his letters 'Absolutely – it's handwriting for the modern age.' He then added that fonts can be simply competent, but they can be competent and friendly. Asked what is needed to be a type designer he said: 'To be a type designer you need patience! Then there are three other

A selection of Michael Harvey's traditional typefaces.

Madrid · Saragossa · Valencia
Barcelona Balthasar Granada
Seville Cadiz

ABCDEFGHIJKLMNOPQRSTUVWXYZ
abcdefghijklmnopqrstuvwxyz
1234567890

things you need: firstly you need a concept or idea, then to be able to turn that into a crafted design and lastly you have to be able to produce it.'

Some designers have a recognised style while others produce a wide variety of designs. Over their range some designers reveal their own characteristics through their type designs, in the way that such things show in their handwriting (though not necessarily when things were commissioned for a special purpose). When you think about this why not? When it comes to typefaces our own preferences are pretty firmly entrenched. Some we like and some we do not. If you choose a default typeface for your computer, or alter it for a special letter it may be telling something about yourself, in the way your handwriting does. Michael Harvey told me this story that put this all into perspective and ties up nicely with what was said in Part 1: 'People say that all my typefaces have a similar look about them. Of course they do. They are the product of my hands.' Elsewhere

More examples of Michael Harvey's typefaces.

gulliver's travels
lord of the rings
uncle tom's cabin

he wrote: 'Drawing is the key. Drawing frees the hand from the demands of the broad-edged pen and the sign-writer's brush. The pencil and neutral eye and mind are in control. Since the arrival of moveable type the written letter has taken a back seat. Type is now the model for the Western alphabet.'

Tim Donaldson continues on that subject saying: 'The alphabet is one of the greatest inventions; while the advent of type – printed alphabets – has curtailed any real development in the shapes of letters, the alphabet has been more utilised in the last 500 years than ever before.'

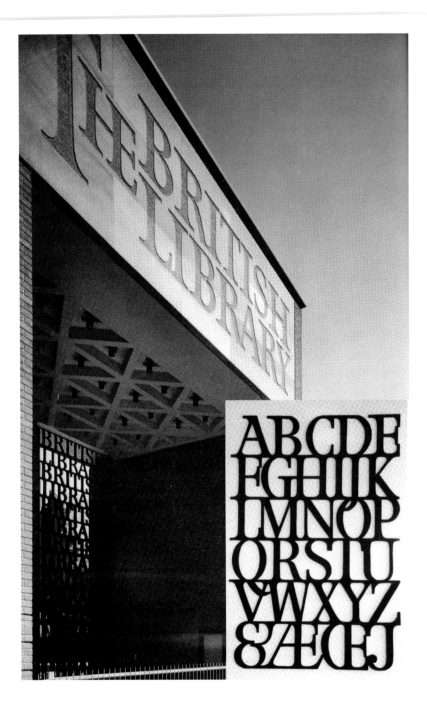

Part 5

Carved, Cut and Engraved Letters

This is about the effects of the most serious and long-lasting kind of letters. They make up the inscriptions on our historic buildings and on humble tombstones in our graveyards. The public may not notice details of the beautiful inscriptions in churches or on public buildings. They may take in the message but what about the letterforms and design? In a sense, that it their purpose, to inform and record – to be so appropriate for their surroundings that they do not interfere or make a strong visual impact (except for those who love to inspect their individual beauty). They are there forever, or anyhow for the foreseeable future, so tend to be designed in a traditional way although it is impossible not to be influenced to a certain extent by changing styles. That is the fascination of graveyards and cemeteries – to help chart the social history of the area. At a more familiar level, they mark our house

David Kindersley's bold experiments with alphabets in the 1960s were the inspiration for the British Library gates. The gates follow through from the format of the carved letters. The cast bronze gates have light letters at the top, with plenty of space between; as we descend they become heavier. At the bottom the lettering is very solid with few spaces (discouraging would-be intruders including small children!).

names and numbers, once again expressing the personal choices and characters of the owners.

These letters are three dimensional, not two as with drawn or typographic letters. They are forms, not shapes even though they may have been drawn before cutting.

Letter cutting is usually a lifetime's commitment, often starting with some kind of apprenticeship. The book by David Kindersley, his wife Lida Cardozo Kindersley and Martin Gayford, says it all in its title: *Apprenticeship – The Necessity of Learning by Doing*. Forget the idea of a young and struggling Dickensian apprentice. Today, most of the Kindersley Workshop apprentices have finished their studies, many are graduates ready to commit themselves to the long and arduous training. Lida explains the concept further: 'With apprenticeships we are talking

Above David Kindersley with two of his sons.

Left The youngest apprentices. Two of Lida and David's sons, now adult, are involved with the workshop today.

To illustrate the kind of work done in the workshop, founded by her husband, David, that she now runs, Lida has provided examples of typical workshop commissions that were all undertaken during one year. They vary from quite simple examples to personal memorials and work destined for public buildings.

A sundial is a precision tool that positions us in the universe. This one at Selwyn College, Cambridge, documents hours since sunrise (gilded lines) or since sunset (white lines). Babylonian (left) and Italian time (right) are explained in lettering on the bottom edge. The Latin inscription is for the benefactor: 'a Yorkshire dairyman gave me to his college for a gift'. A few flourishes are introduced here to fill the spaces. The Greek above is 'Know the time', with the subtext 'seize your opportunity'.
Welsh slate 2'10" x 3'6" x 1".

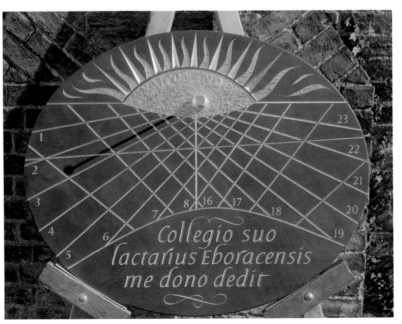

QUIET
please

In memory of
PETER JOHN DIXON
of Clothall House
1915-2007
Benefactor of this Parish
And of his beloved wife
MARGARET HOPE DIXON
1916-1999

Of the three main letter forms, capitals are for the basic hard information, like names and dates. Upper and lower case together is good for commentary, and italics allow a softer, flowing or even emotional gloss on the individuals commemorated. Blue/grey slate 19" x 23".

Stages in the making of a headstone: we draw with a normal 2H pencil onto the stone, and then cut from the bottom up. And we sit upright for it. This position has three important advantages: we can judge proportions/lay-out and step back for a better view; we stand or sit upright with a straight back rather than crouch; the dust from the cut falls away with no need for brushing, which would also erase our pencilled setting-out. York stone 2'6" x 18" x 3".

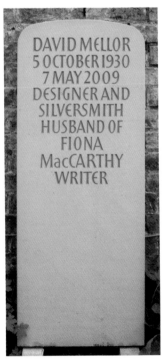

DAVID MELLOR
5 OCTOBER 1930
7 MAY 2009
DESIGNER AND
SILVERSMITH
HUSBAND OF
FIONA
MacCARTHY
WRITER

about the accumulated knowledge of the past being handed down within a working environment. Learning is done on a real job; it is quite different from an art school, where the student is only there to be graded at the end.'

The workshop also undertakes glass engraving. Many years ago, when watching Lida working on such a commission she demonstrated a most unusual skill. A left-hander, she was able to mirror write from right to left. This was useful as she could then mark out the words on the reverse of glass. At that time she said: 'The great excitement of glass is its transparency and to make this work one has to work all round and through the glass to get away from the idea of a design that only works when seen from one view. Consider and take advantage of the reflections from the engraving.'

Glass is altogether more frivolous than stone, and that is reflected in the lettering. The contrast between the letters and their background is a matter of texturing, using a dentist's drill. Glass roundel 50cm.

These are the end papers reproduced from the book,
Remembered Lives, that Lida co-authored with David Meara.
This illustrates the complex course taken from the initial
commissioning of a memorial, through the design process to

the final fixing in place of the stone. It highlights the sensitive relationship between craftsman and bereaved client to satisfy all their requirements.

This is a flowchart of the process for commissioning a stone memorial in a church.

Letters woodcut

The Cardoza Kindersley Workshop working together on carving letters into a solid oak beam. Wood chisels need to be very sharp to deal with the grain – dangerous in contrast to stone chisels.

Letters carved in wood have a slightly different effect on us to those cut in stone. They are somehow warmer, more immediate and personal, and they often tend to fulfil a somewhat different function and different needs in our lives. They are not meant to last quite as long as stone, but are permanent nonetheless. I think of a beautiful alphabet carved on what might be called a roundel or plaque. It was given to me by the late Will Carter, Master craftsman in letters cut, carved or printed. He said that it was a bread board, not a plaque or roundel and trusted that I would always use it as such. I have never dared actually to cut bread on it for fear of defacing it, but it appears on my table whenever we

The Rampant Lions Press

The Queen's book

have a cheese, bread and biscuit meal. It is a constant reminder of a wonderful friend and something that always causes visitors to notice and praise. As Martin Wenham puts it: 'Such things have a voice, they are spoken through the eyes.'

Martin came to this work originally because of his love of wood – the lettering followed. He explains how wood and stone offer immediate and sharp contrasts to both sight and touch. 'Wood is softer, less dense and has its own distinctive forms and internal structures that develop as it grows. To cut letters in wood requires entirely different techniques from those used in stone. The ideal wood for letter-cutting is fine grained and moderately hard, but above all tough, that is, resistant to

Above: Will Carter's work.

Right: Martin Wenham states that good wooden signs can be made relatively cheaply and add significantly to the quality of the environment.

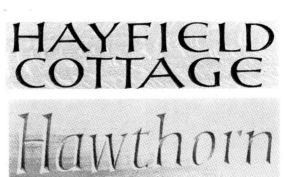

HAYFIELD COTTAGE

Hawthorn

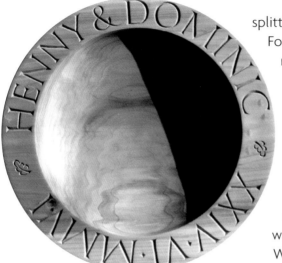

splitting along the grain. For work that is to remain indoors the fruit woods (apple, pear, plum, cherry) and holly are all excellent. For work that has to withstand weathering the only suitable British wood is oak.

Wood is for the letter designer and cutter not merely a raw material. Colour, form and texture, both natural and man-made can be combined to make it a material with a very wide range of visual and tactile properties. This in turn can contribute positively to the design process and the overall impact of the finished piece of work.'

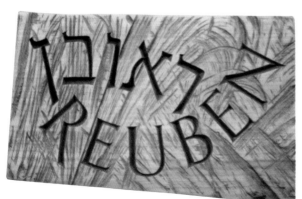

More examples of Martin Wenham's work.

Above: A bowl (left) and a platter (right).

Left: A name piece carved in applewood for the son of a friend.

Right: words from *The Wild Swans at Coole* by W B Yeats.

He continues in *Silent Voices*, a catalogue accompanying an exhibition of his work: 'The majority of my work is done on quite a small domestic scale, using scrap or found materials from beaches, woodyards or the workshops of other makers. In most cases the workpiece is not simply raw material on which I impose a design, but a major contributor to the design process, quite often suggesting the text as well. Sometimes the wood is kept for years until the right words arrive, at other times the situation is reversed and the words have to wait for a piece of wood which can enable them and their meaning to be communicated effectively.'

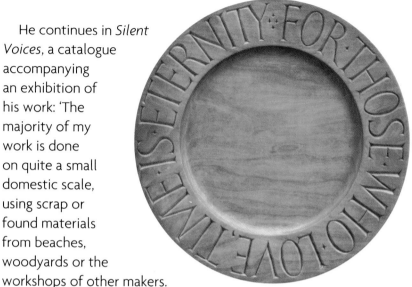

Their hearts have not grown old;
Passion or conquest, wander where they will,
Attend upon them still.

A memorial to men who lost their lives in the Second World War in the chapel of Fitzwilliam College Cambridge, by Martin Wenham.

In memory of those who gave their lives in the Second World War 1939-1945

T. HUMPHREYS * D.G. IMAGE
E.V. KNOWLES * G.T. LOWRY
J.N. MAAS * G.F. MEASURES
I.T. MEASURES * C.W. OLIVE
J.E. OLIVER * M.H. PARRY

The wood for *Wild Swans* came from a felled sycamore tree in a friend's garden. When split from the stem it looked like a wing, and was then trimmed to the present shape. It suggested to me these words from The Wild Swans at Coole by W.B. Yeats.

Martin, however, does undertake larger commissions, for example the memorial for Fitzwilliam College Cambridge illustrated here.

Postscript

I hope that in putting this book together we have led to a deeper understanding of how letterforms affect us all. Thanks to the contributors, others may now understand more about why the fascination of letters, in whatever form, can fill our lives. We have explained in different ways, how we work and how in turn our work can affect you.

What comes out of discussions with this close-knit group of friends and colleagues is what a satisfying life our interest in letterforms, in whichever form, gives us. Whether we are practising our skill, teaching it or writing about it, we are doing what we love, with no need to retire.

We also hope that what we have produced will, in some way, help everyone to notice and enjoy the letters all around them in their environment.

References

Blunt W. 1953, *Handwriting A Practical Approach to the Italic Hand*, James Barrie.

Callewaert H. 1962, *Graphologie et Physiologie de l' Ecriture*, Nauwelaerts, Louvain.

Kindersley D. 1969, *Variations on the Theme of 26 Letters.*

Cardozo Kindersley LL, Hoare L. and Sherwood D. 2003, *Cutting into the Workshop*, Cardozo Kindersley.

Carter W. 1993, *Some Book-labels Designed by Will Carter*, The Rampant Lions Press.

Clayton E. 2013, *The Golden Thread, The Story of Writing*, Atlantic Books.

de Brunhoff L. 1934, *The Story of Babar,* Methuen.

Delf Smith PJ. 1946, *Civic and Memorial Lettering*, Adam & Charles Black.

Donaldson T. 2008, *Shapes for Sounds*, Mark Batty Publisher, New York.

Gayford M, Kindersley D. and Cardozo Kindersley L, 2003, *Apprenticeship,* Cardozo Kindersley.

Harvey M. 2012, *Adventures with Letters,* 47 Editions.

Kindersley D. 1969, *Variations on the Theme of 26 Letters.*

Mahoney D. 1981, *The Craft of Calligraphy*, Pelham Books.

Meara D, Cardozo LL, 2013, *Remembered Lives,* Cardozo Kindersley.

Pludwinski I. 2012, *Mastering Hebrew Calligraphy*, The Toby Press.

Sassoon R. 2000, *The Art and Science of Handwriting*, Intellect.

Sassoon R. 2010, *Keeping Chronicles, Preserving History Through Written Memorabilia.* A&C Black.

Wenham M. 2013, *Silent Voices, The Language of Art,* Goldmark.

Index